THIS NOTEBOOK BELONGS TO ..

CONTACT ..

See our range of fine, illustrated books, ebooks, notebooks and art calendars:
www.flametreepublishing.com

This is a **FLAME TREE NOTEBOOK**
Published and © copyright 2022 Flame Tree Publishing Ltd

FTNB309 • 978-1-83964-893-9

jz JENNY
ZEMANEK

Design inspired by J.M. Barrie's *Peter Pan*
by Jenny Zemanek
© Jenny Zemanek, licensed by Jehane Ltd

Jenny is a lifelong lover of all things creative. What started with happy scribbles at a young age, grew
into a pursuit of photography and graphic design before she found a home with illustration and hand-lettering.
She lives in Columbus, Ohio with her husband and two rescue dogs. Jenny revels in the joys of small decorative
details and finding ways to add personality to her work. Inspired by a deep love of both literature and lettering,
this series of designs truly reflects the beautiful intersection where two creative passions meet and flourish.

FLAME TREE PUBLISHING | The Art of Fine Gifts
6 Melbray Mews, London SW6 3NS, United Kingdom